YOU CAN DRAW
HORSES

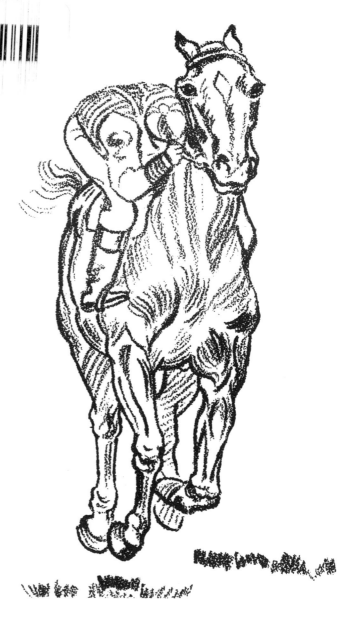

VICTOR PERARD

REVISED BY
GLADYS EMERSON COOK

DOVER PUBLICATIONS, INC., MINEOLA, NEW YORK

Bibliographical Note

This Dover edition, first published in 2006, is an unabridged republication of *Drawing Horses,* originally published by Pitman Publishing Corporation, New York, 1956.

Library of Congress Cataloging-in-Publication Data

Pérard, Victor Semon, 1870–1957.
 [Drawing horses]
 You can draw horses / Victor Pérard ; revised by Gladys Emerson Cook.
 p. cm.
 Originally published: Drawing horses. New York : Pitman, 1956.
 ISBN 0-486-45112-7 (pbk.)
 1. Horses in art. 2. Drawing—Technique. I. Cook, Gladys Emerson, 1899– II. Title.

NC783.8.H65P47 2006
743.6'96655—dc22

 2006045452

Manufactured in the United States of America
Dover Publications, Inc., 31 East 2nd Street, Mineola, N.Y. 11501

INTRODUCTION

To DRAW properly, it is important to have and to know how to use the correct tools and materials.

Tools and Materials

The easiest medium for you as a beginner to use is a soft (#5B or #6B) pencil. You can obtain a much freer, flowing line than with other pencils, and mistakes can be easily erased. At this stage you may draw on a pad of inexpensive paper. You may wish to use a sketch pad.

If you are sketching out of doors, attach the sketching paper to a board with a thumbtack, or slip a large elastic band around the sketch pad and board. For a thicker and denser line, use a charcoal or crayon-othello #1 or #2 pencil. Do not use these pencils until you have had considerable practice.

A kneaded eraser is the best material to use for correcting any mistakes that you may make when using any of the above materials.

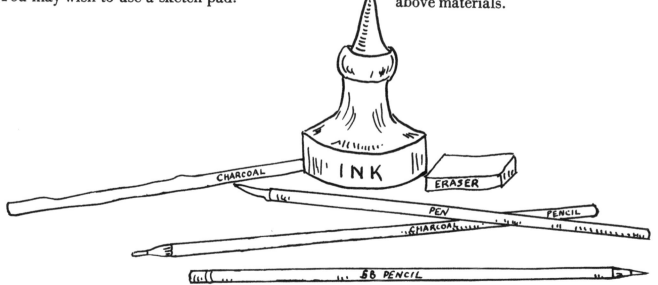

Pen and india ink, or brush and ink, are both excellent to work with. Use a croquil pen and india ink for fine line sketching. A brush (use a No. 6) gives a soft and interesting line. Before drawing, dip the brush in the ink and wipe it nearly dry on a blotter.

Analyze Your Subject

Before starting to sketch, analyze your subject carefully. Study the proportions, that is, the length and width compared with the height.

Arrangement of Drawing

Decide where you are going to place the drawing on the paper, and keep the drawing in proportion to the size of the sheet. Do not crowd the drawing into one corner of the paper.

Preliminary Drawing

Sketch the outline of your subject with your finger on the paper before drawing with a pencil. Then, sketch in lightly with a pencil, and finally, when you are sure of the true lines, go over the sketch with a more definite line.

Composition

To test your composition, hold the sketch in front of a mirror and see it in reverse. Often, defects in composition which are not normally apparent show up clearly in reverse.

BASIC LINES

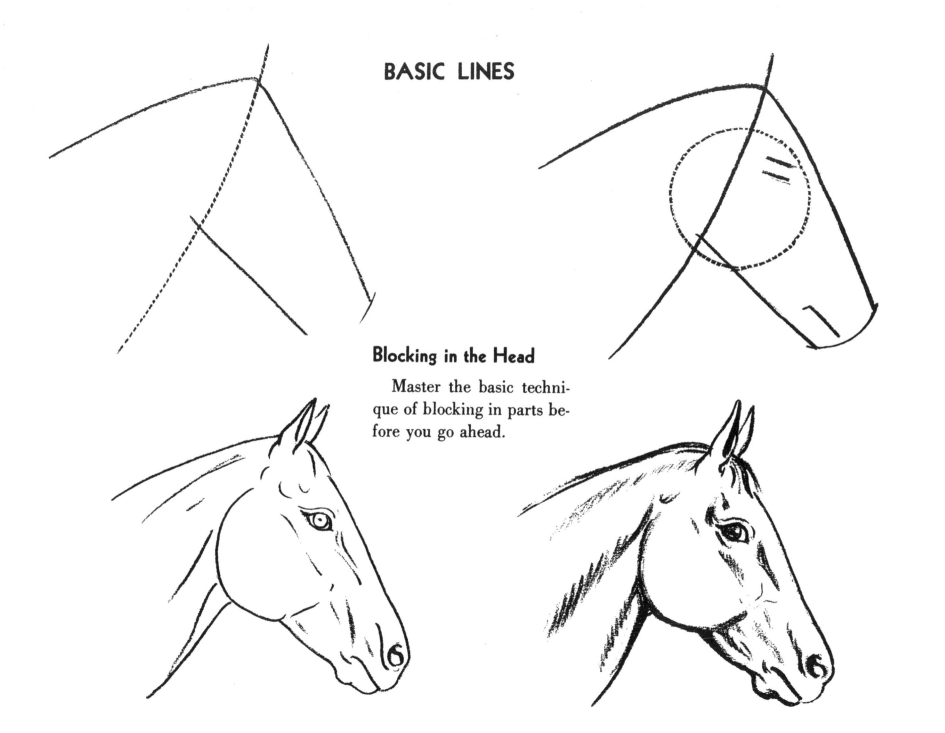

Blocking in the Head

Master the basic technique of blocking in parts before you go ahead.

Lines of the Body

Conventionalize the form of the horse to get the basic expression and lines of action.

PROPORTION AND ANATOMY

Proportions of the Parts

When sketching, memorize the proportions for future use.

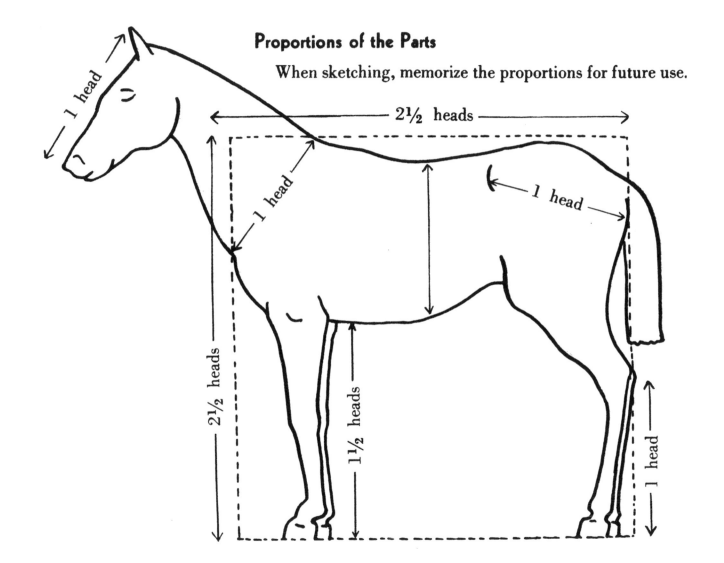

1 head

2½ heads

1 head

1 head

2½ heads

1½ heads

1 head

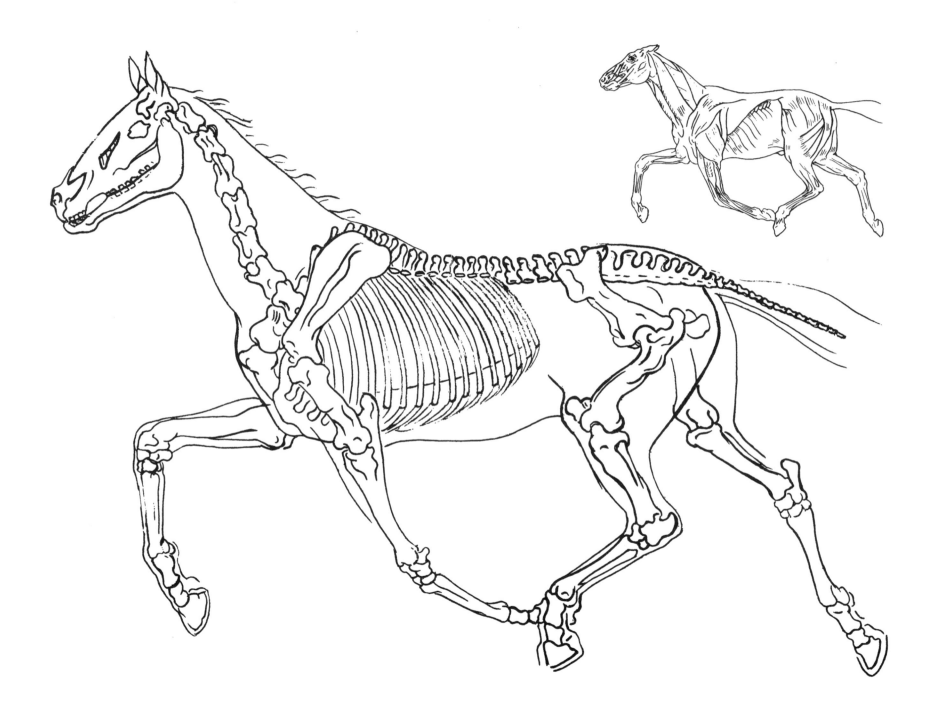

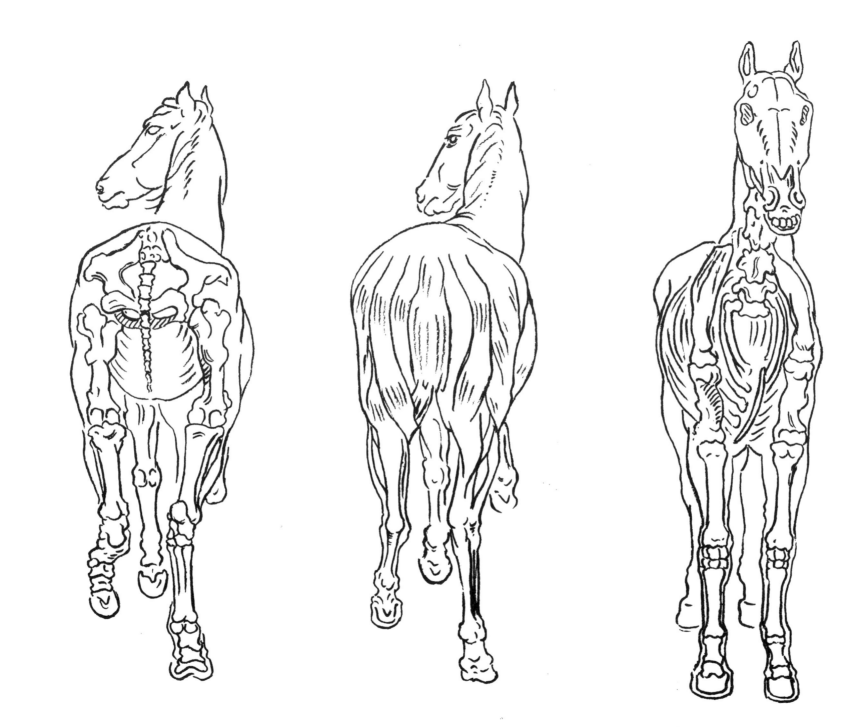

The Head

In order to understand the surface form, it is necessary to know something of the underlying structure.

Bones
1. Frontal
2. Parietal
3. Occipital
4. Temporal
5. Nasal
6. Lower jaw

Muscles
1. Masseter
2. Temporalis
3. Orbicularis
4. Dilator naris latoris
5. Zygomaticus
6. Levator scapula
7. Sterna maxillaris
8. Deltoid

By looking at these two drawings you will see how muscles act in a galloping horse. By careful study of the left-hand drawing you will see how each muscle acts on its own particular part of the body. By doing this you will be able more easily to draw the picture.

Muscles
1. Mastoid humeralis
2. Sterno hyoid
3. Point of breast bone
4. Pectoralis
5. Triceps
6. Latissimus dorsi
7. External carpi radialis

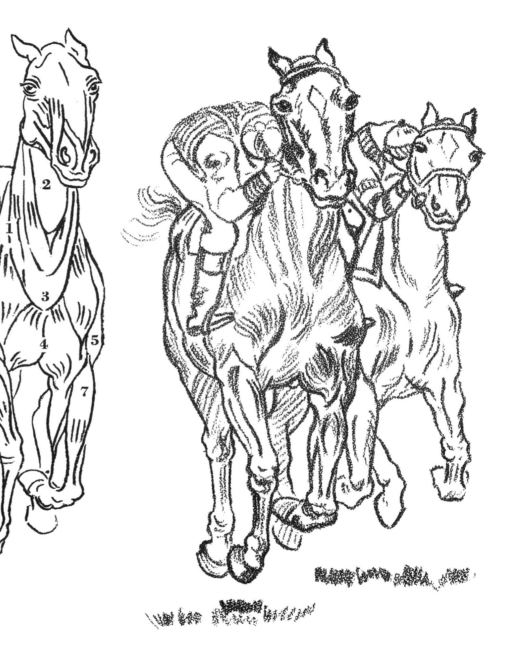

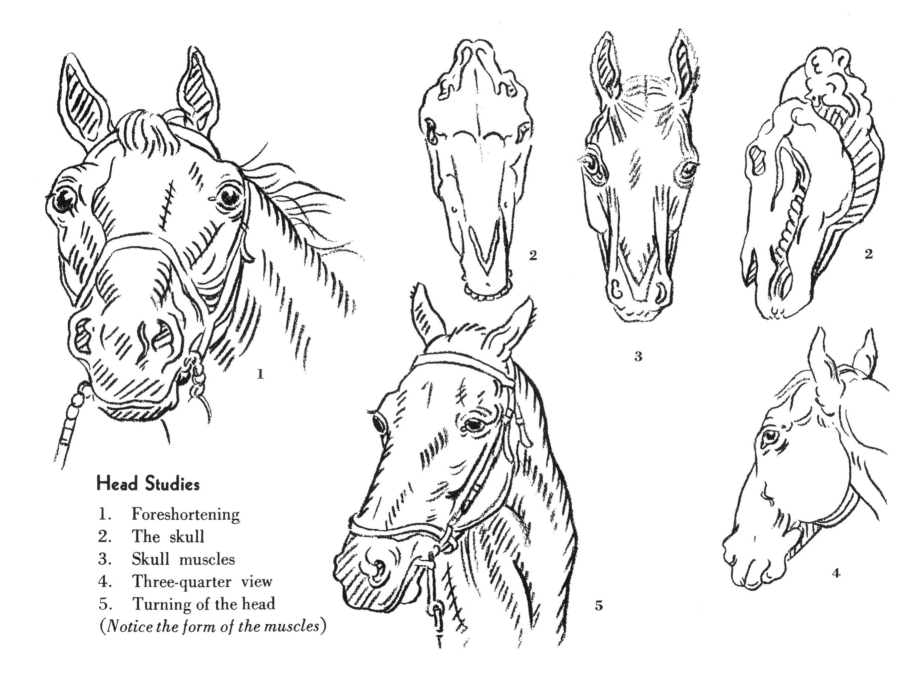

Head Studies

1. Foreshortening
2. The skull
3. Skull muscles
4. Three-quarter view
5. Turning of the head
(*Notice the form of the muscles*)

Studies of Horses' Legs

The legs show action. Note the muscle tension.

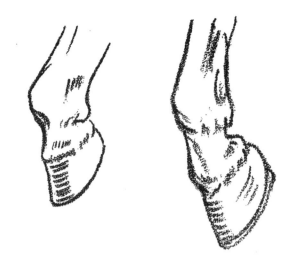

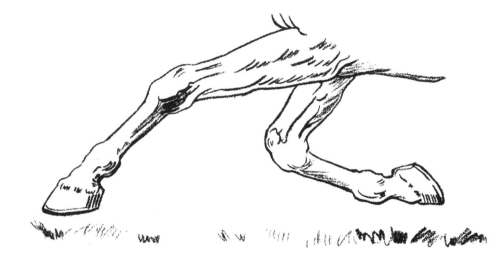

Hoofs

When drawing the horse, remember that the whole weight of the body is carried by the four hoofs. Therefore, when you do a study of a horse standing, draw the hoofs so that they appear solidly placed on the ground, and make them large enough.

Notice particularly how the fetlock narrows immediately above the hoof.

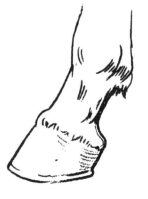
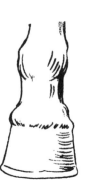
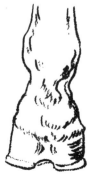

Front Leg

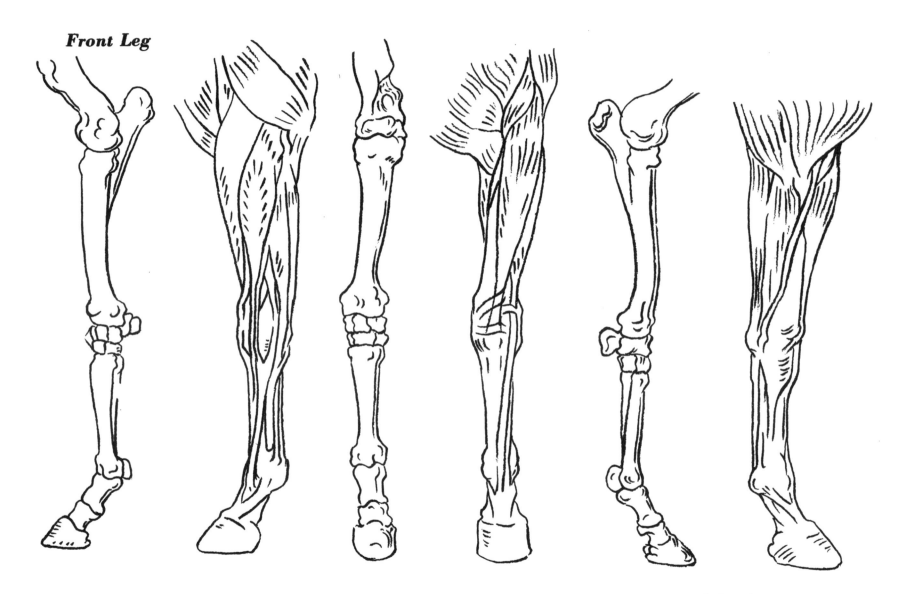

Side view Front view Side view

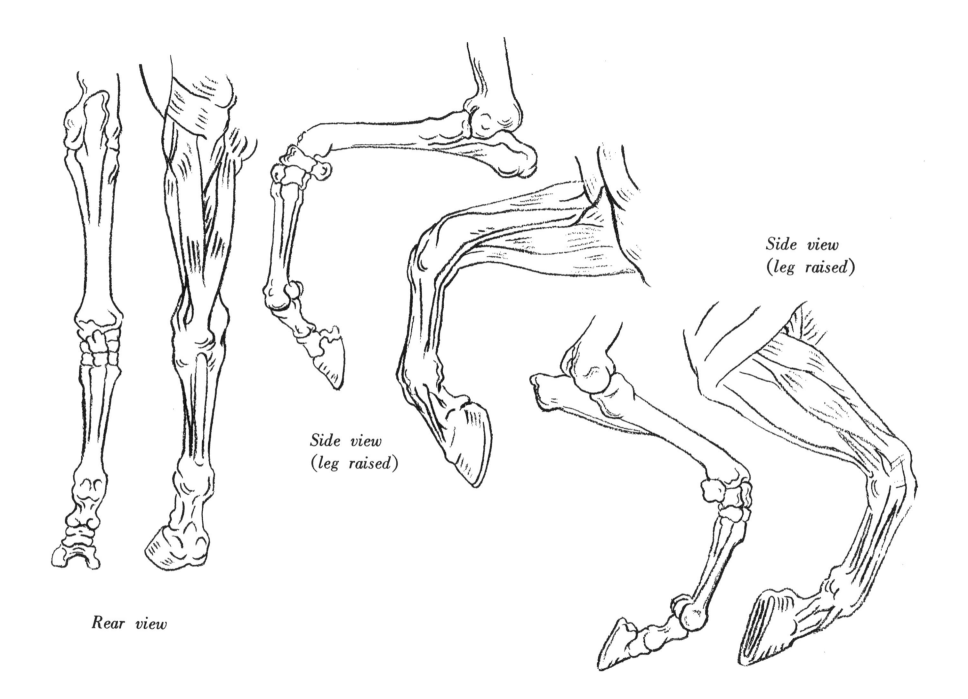

Rear view

Side view
(leg raised)

Side view
(leg raised)

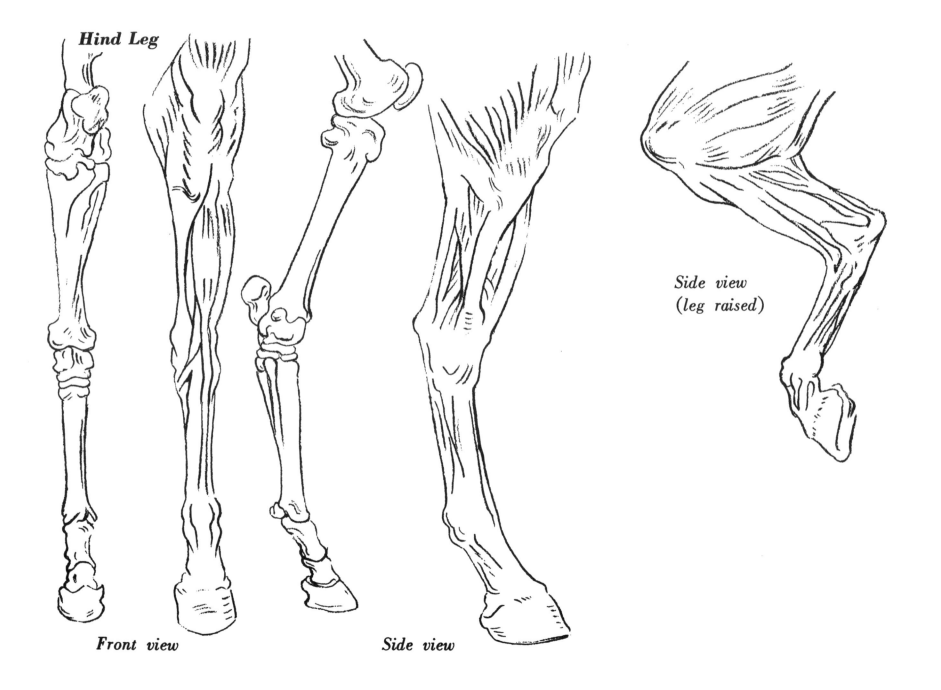

Hind Leg

Front view

Side view

*Side view
(leg raised)*

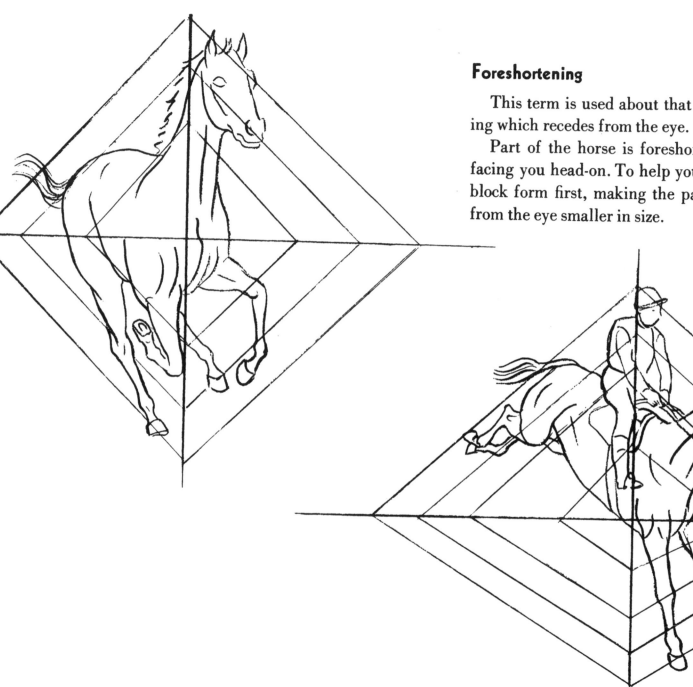

Foreshortening

This term is used about that part of the drawing which recedes from the eye.

Part of the horse is foreshortened when it is facing you head-on. To help you draw this, use a block form first, making the parts which recede from the eye smaller in size.

HORSES IN ACTION

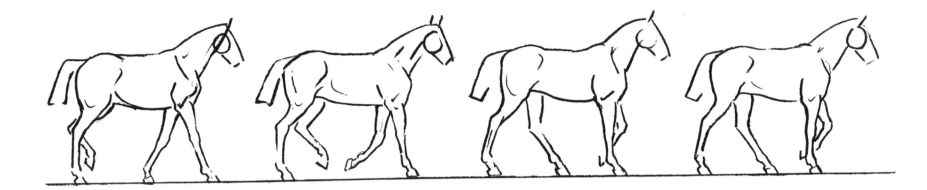

Progressive Movements —Walking

Notice the change of balance as the horse moves its weight from one leg to another.

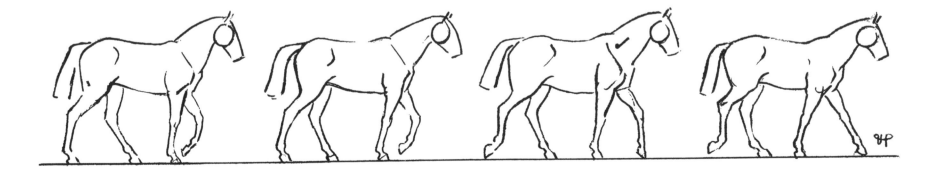

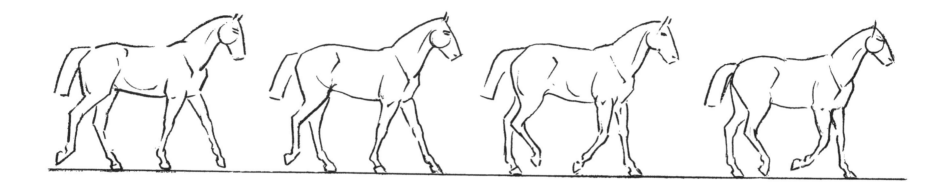
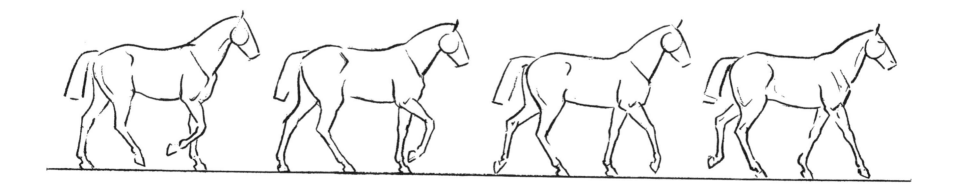

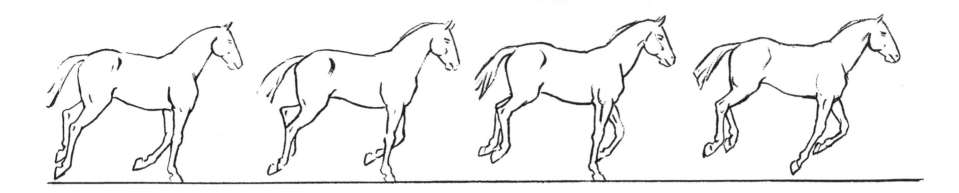

Progressive Movements—Cantering

This is a slow, relaxed gait. The front legs leave the ground at the same time, and are slightly raised, while the rear legs are on the ground. When the front legs are on the ground, the rear legs are slightly raised.

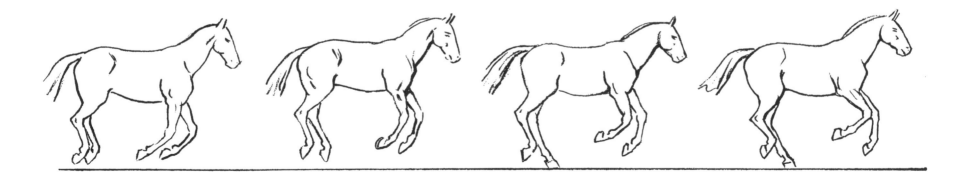

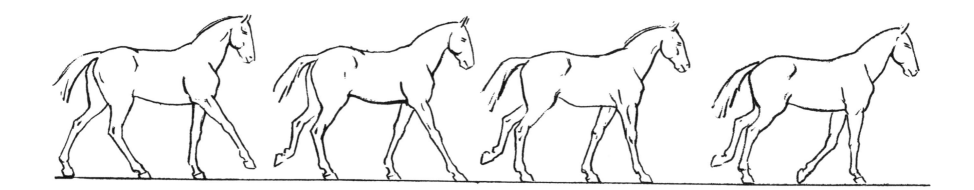

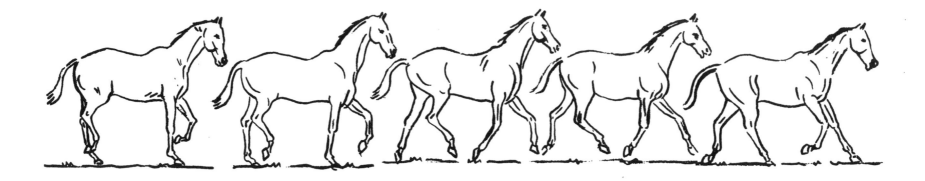

Progressive Movements—Trotting

Study carefully the position of each leg. Notice, particularly, the legs that run in parallel; for example, the left front leg and the right rear leg are both on the ground at the same time. In this way, you will catch the whole movement of the trot.

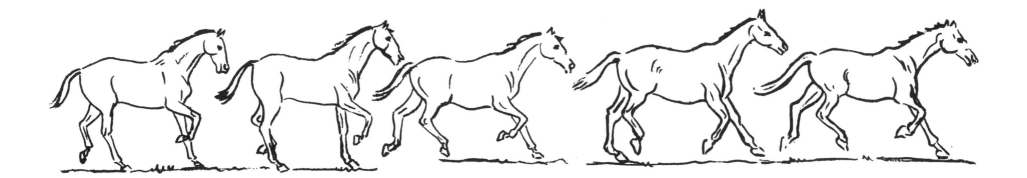

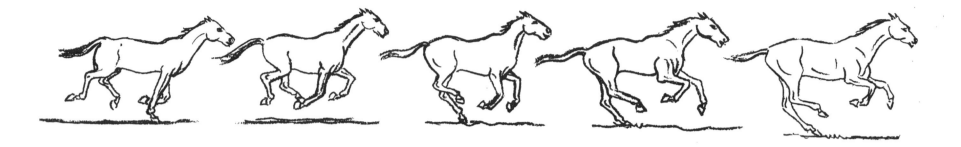

Progressive Movements—Galloping

This is a fast gait. Both of the front legs leave the ground at the same time, followed by the rear legs. Notice that all four legs are often off the ground at the same time.

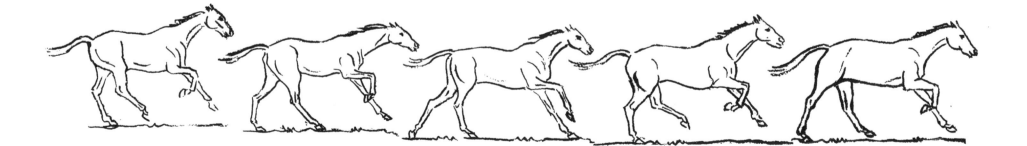

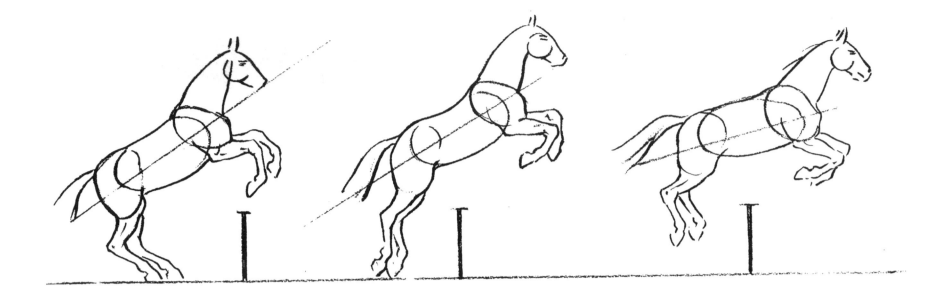

Progressive Movements—Jumping

With each movement, draw a line through the center of the body. This will be a guide to the position of the horse as it goes over the hurdle.

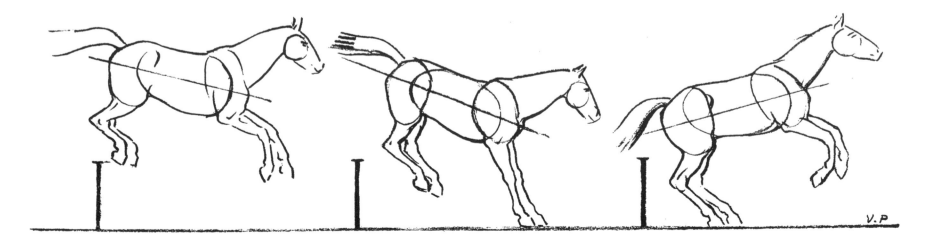

V.P

Wild Horses

First, you should block in the whole study. Notice action lines in relation to the body conformation. Sketch in the swing of the body and then the large areas, keeping in mind the action of the body as a whole.

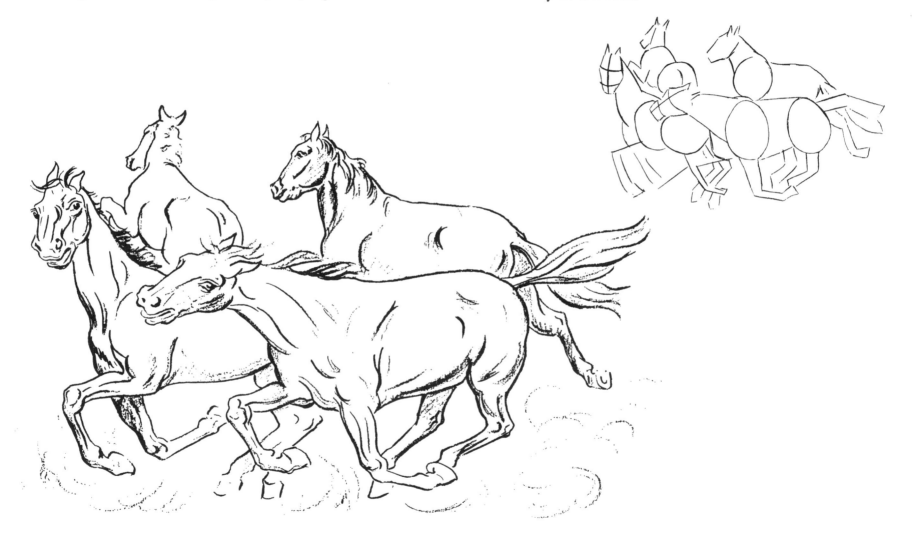

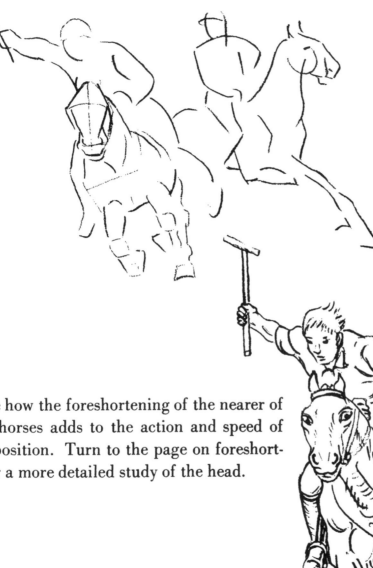

Polo Ponies

These sketches of a polo game will help you when drawing scenes of men and horses in action together. First, draw the line of movement of the horse and then block in the sketch.

Notice how the foreshortening of the nearer of the two horses adds to the action and speed of the composition. Turn to the page on foreshortening for a more detailed study of the head.

The horses and riders drawn at an angle give the feeling of movement. Before blocking, place the angle line through the horse and rider.

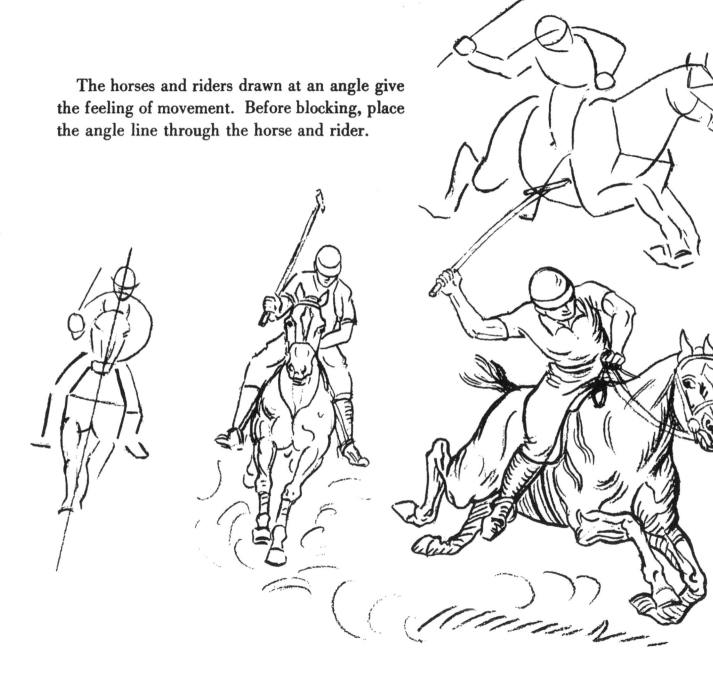

Keep the line in both of these drawings clear and avoid shading. Shading, unless applied very carefully, can ruin an action study. Practice these action studies many times using clear lines only. When you feel competent, try the kind of pencil shading shown on the horse and rider on the next page.

Draw the two players and horses above as one unit, conventionalizing at first wherever the parts of the horses and rider are visible. Gradually fill in the detail.

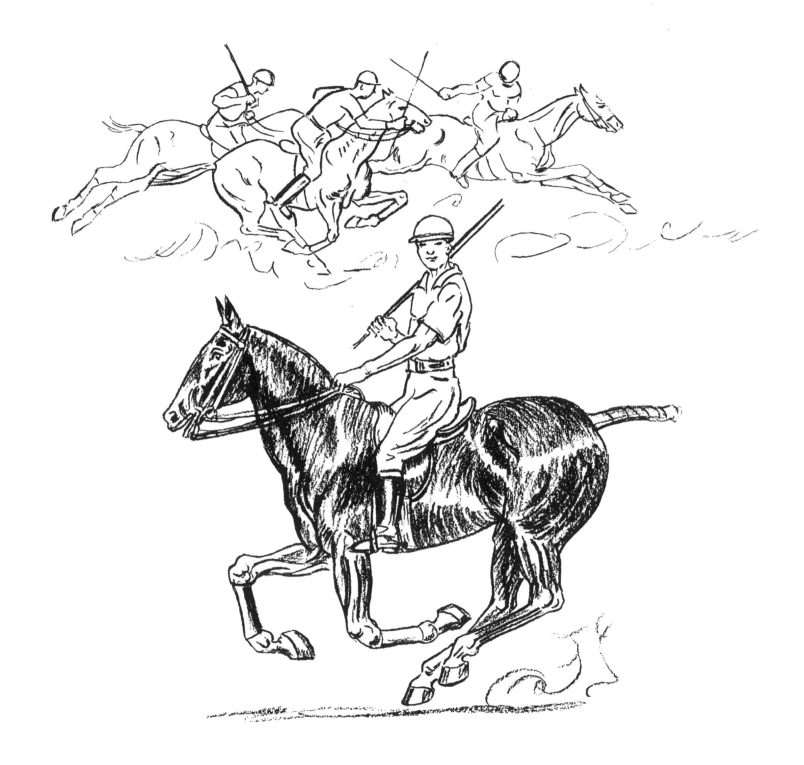

Rodeo

The sketches on the next few pages will give you good practice in drawing studies of the horses and riders working together and against each other.

If you are in difficulty when drawing a galloping horse, turn back to the pages on the progressive movements of a horse galloping. Follow them through carefully before attempting to draw a horse on this page.

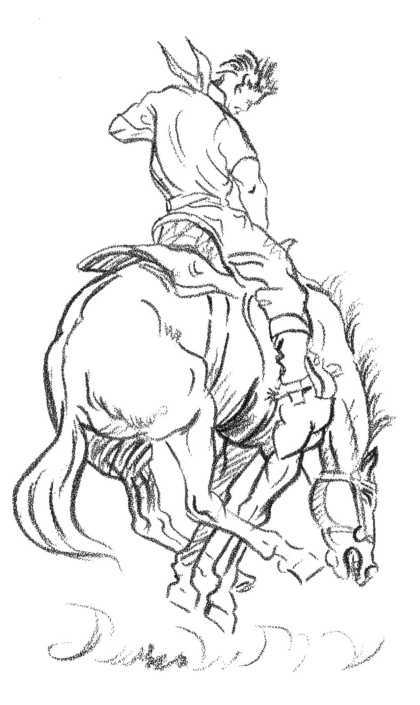

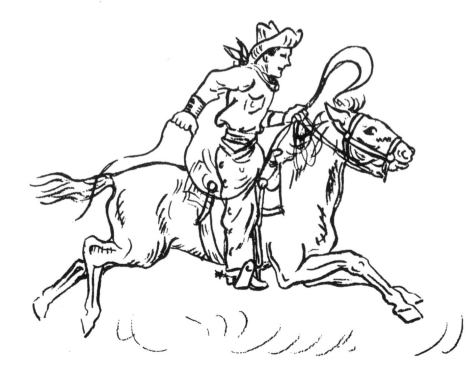

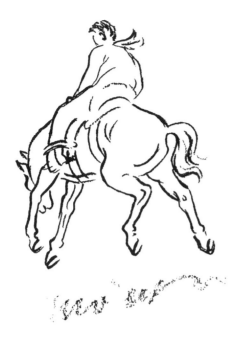
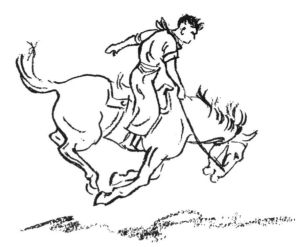
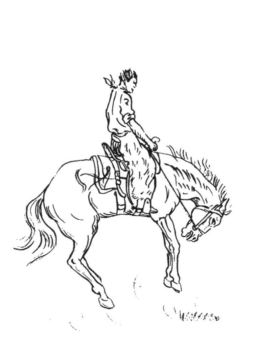
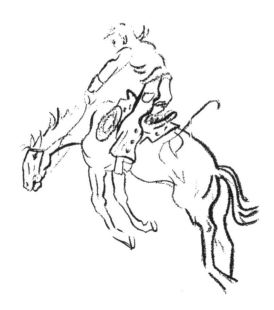
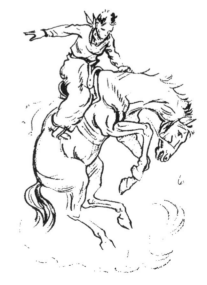

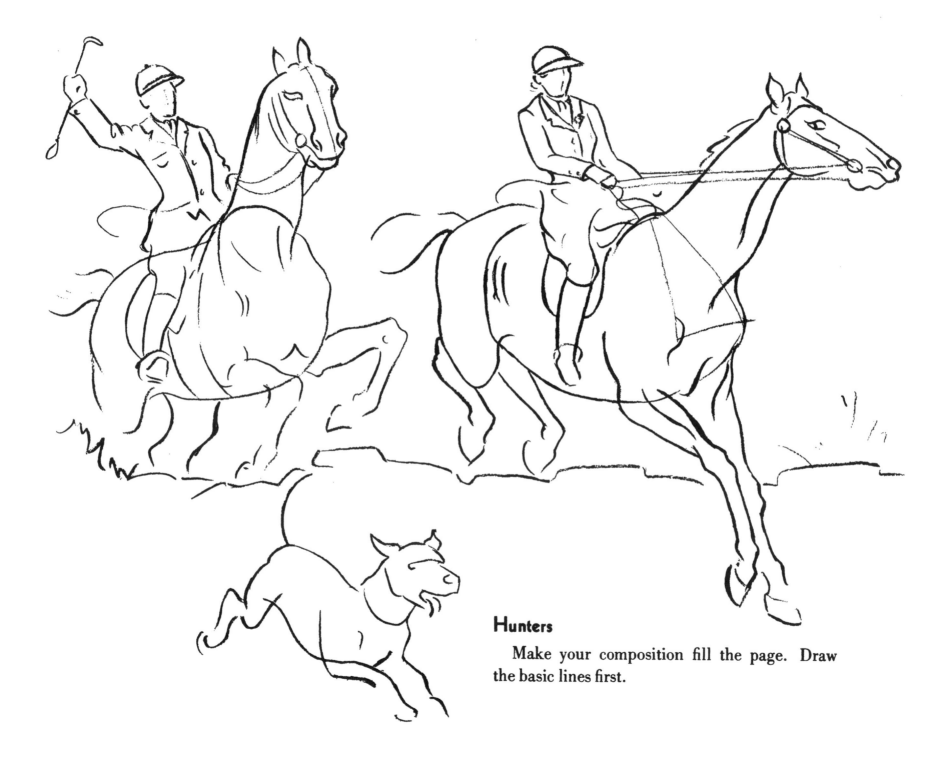

Hunters

Make your composition fill the page. Draw
the basic lines first.

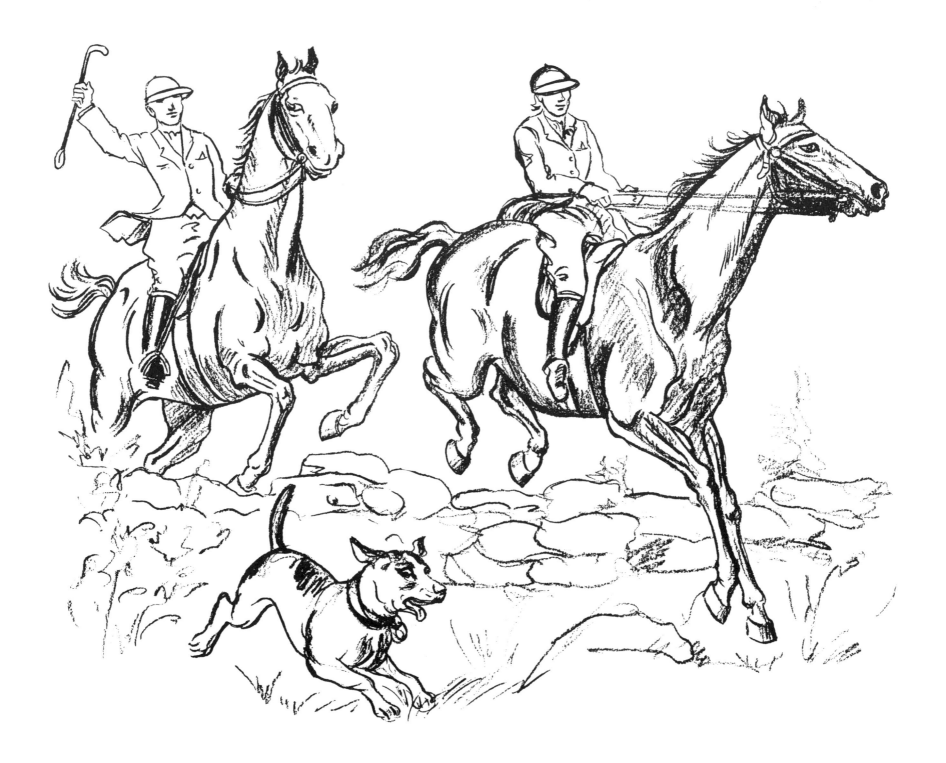

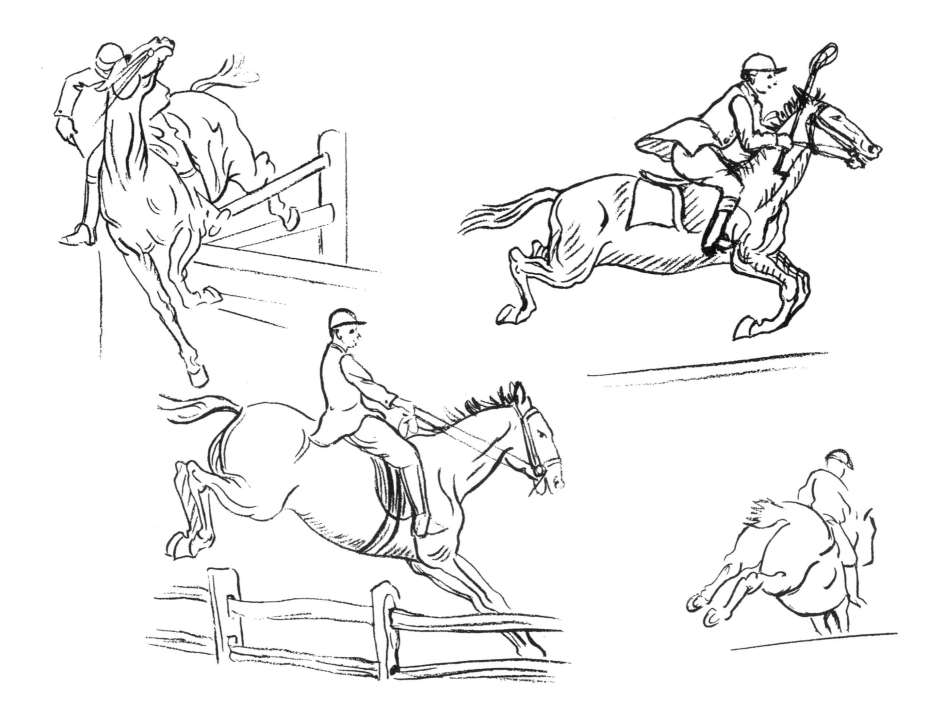

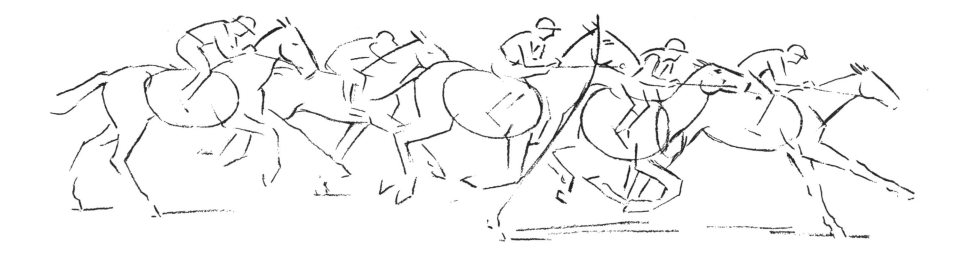

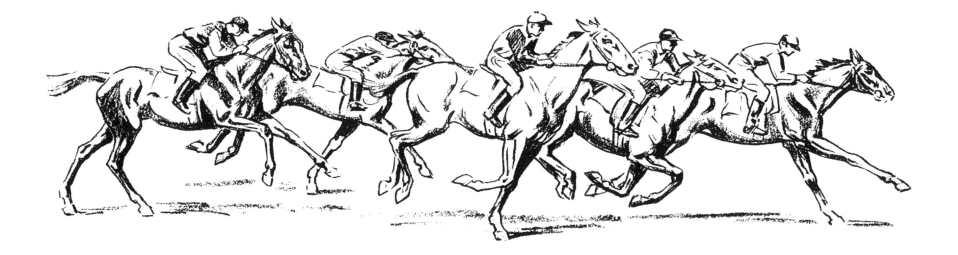

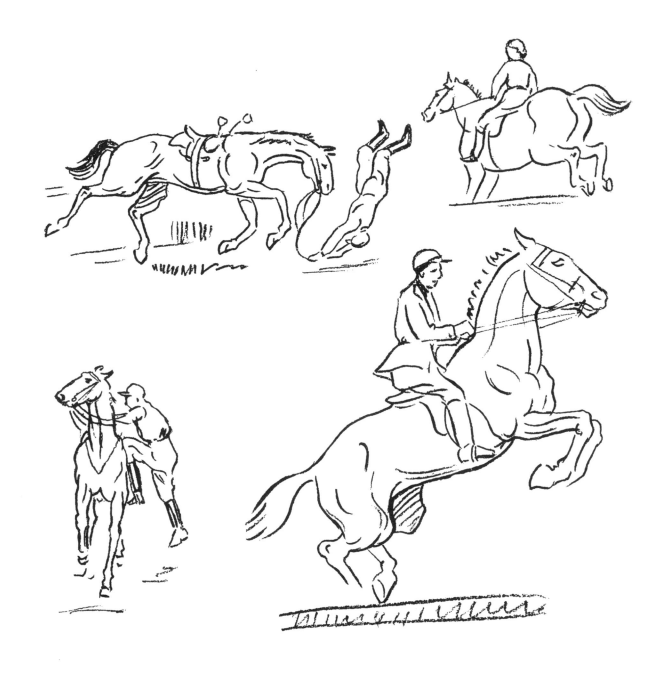
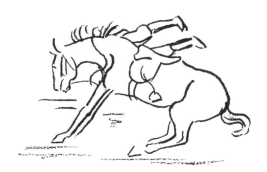
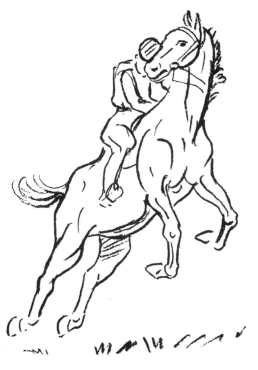

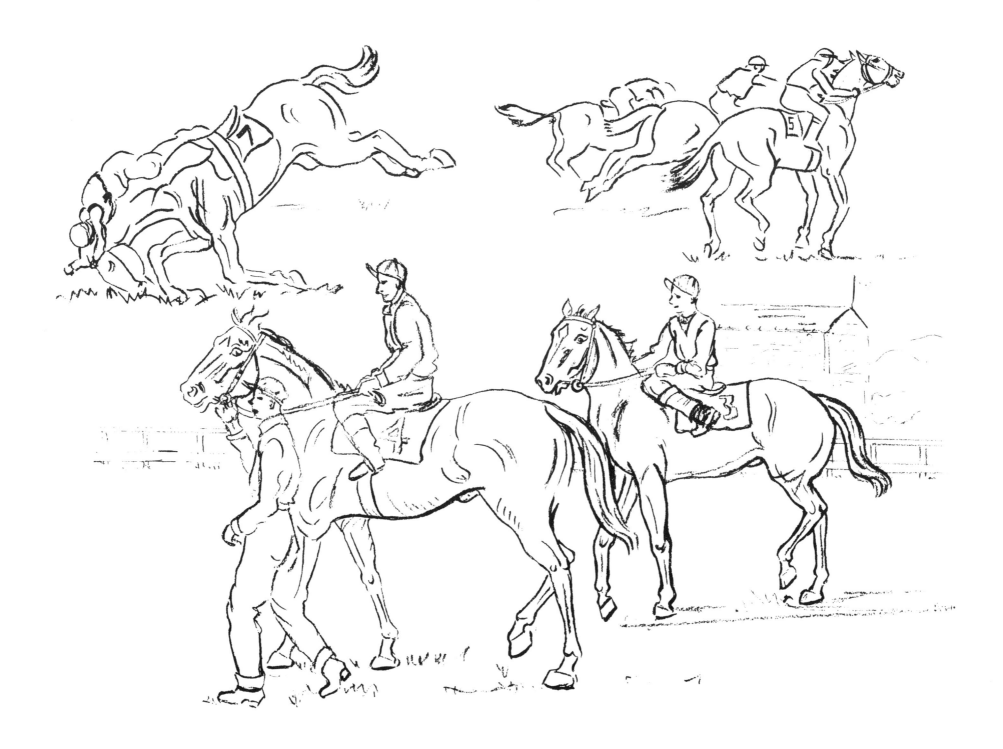

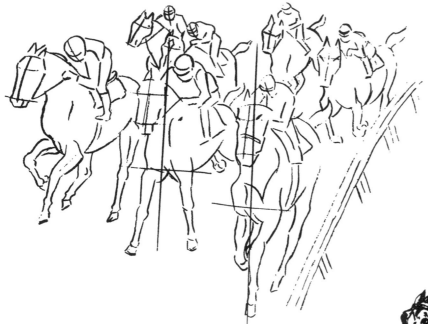

Master the outline of the lines of movement before you attempt the shading.

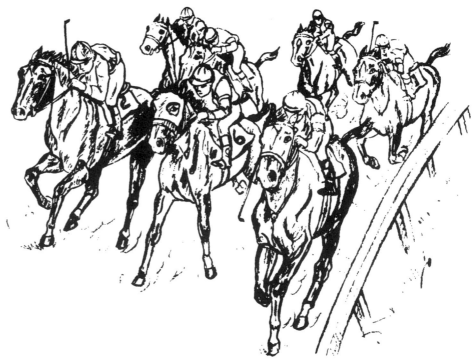

TYPES OF HORSES

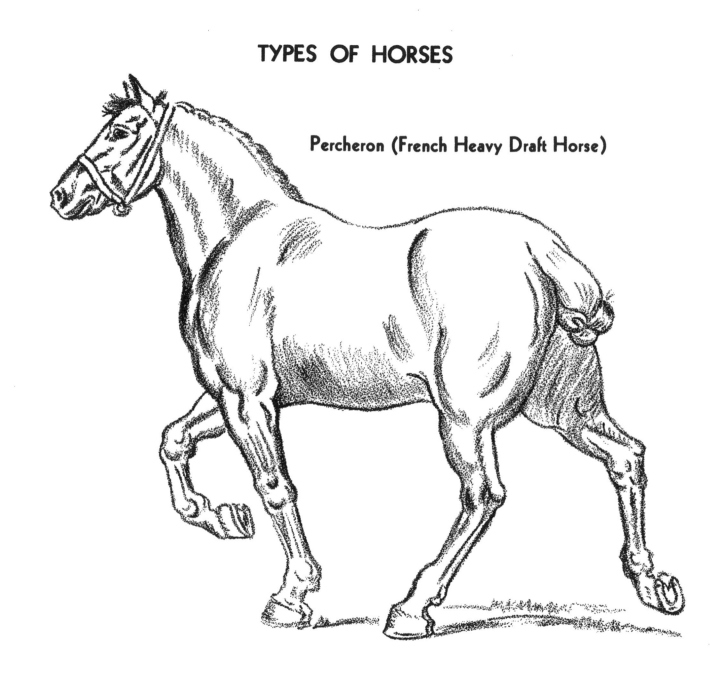

Percheron (French Heavy Draft Horse)

Donkeys

Notice the line of action of the kicking donkey. Draw this first of all so that you will not waste time positioning the drawing a number of times.

Saddle Horse

In study *A*, the outline, proportions, and lines of action of this high-stepping, weight-carrying horse are shown. Drawing *B* shows some of the muscles which affect the outer form in the action. Drawing *C* shows the third dimension. Here roundness and depth is made by shading.

Colts

Draw the line of action first of all. Notice that colts have short necks, long ears, and rounded foreheads.

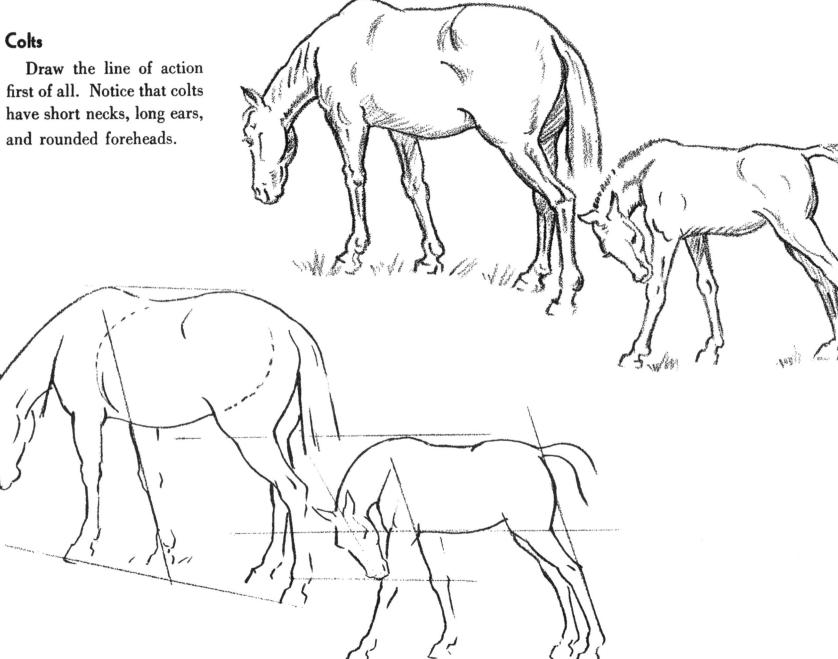

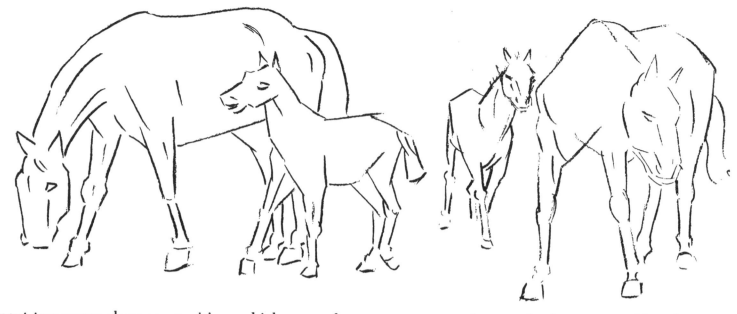

The next two pages show compositions which are perhaps most commonly seen in the countryside; the mare and the foal, and the pair of horses resting. Before drawing the shadow, block in the outline and the lines of action.

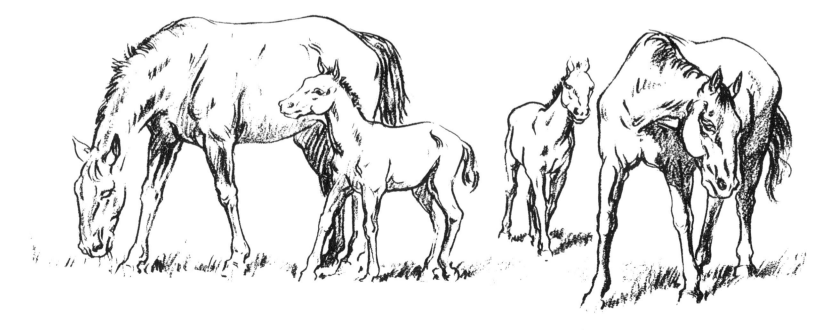

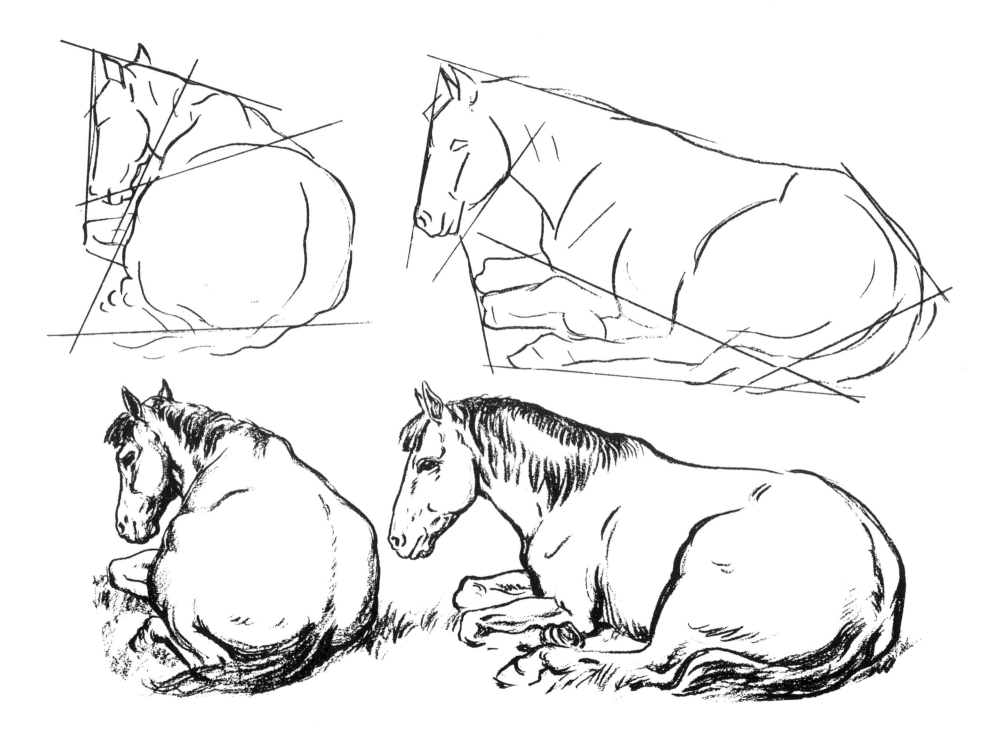

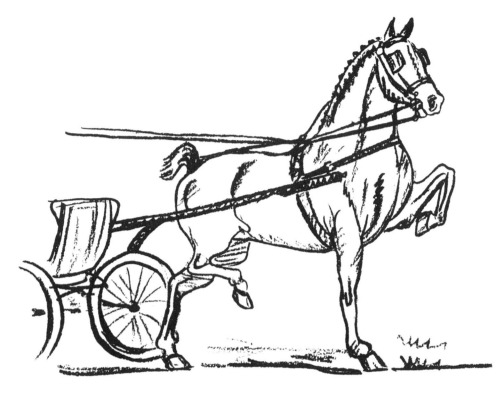

The Horse Show

These three types of horses, the three-gaited, five-gaited, and Hackney ponies, are noted for their walking, trotting, and cantering. In order to be sure of drawing the correct lines of movement, turn back to the pages showing the progressive movements of a horse.

QUICK INK SKETCHES

Pen and Ink Sketching

First, sketch the outline of the subject with a soft pencil, then go over it with pen and ink. To shade areas, increase the pressure on the pen point to produce a wider line. When the sketch is thoroughly dry, erase the pencil mark.

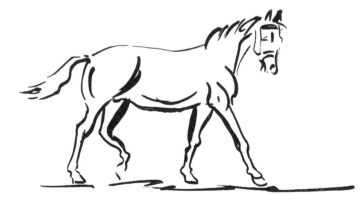

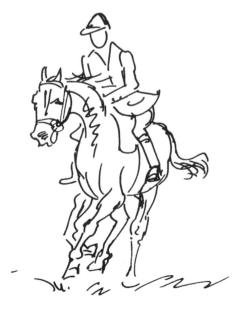

Indicate the action of the body with long swinging pen lines; then make quick supplementary lines for the head and legs.

If you use a brush for these sketches, make sure that you dry off the surplus ink, on blotting paper, before starting your stroke.

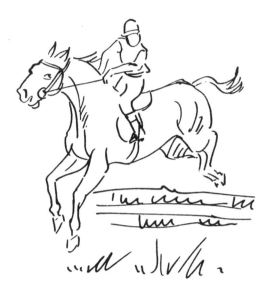

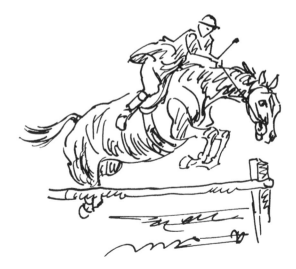

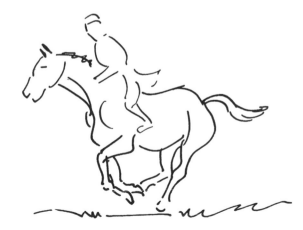

Saddles

In order to draw a composition of horses, you should know something of the accessories. The most important of these is, perhaps, the saddle.

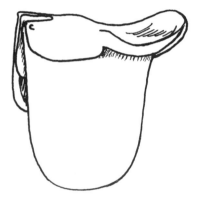

English Saddle. This saddle is the most popular and is used for general riding.

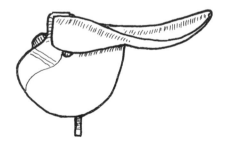

Racing Saddle. A light-weight saddle.

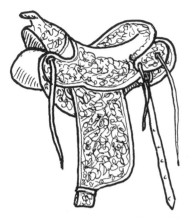

Cutting-horse Saddle. Usually very ornate and handcarved, these saddles are of a Western or Texan type and are used for show and rodeos.

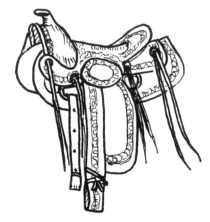

Western Saddle. This saddle is often heavy and is used mostly by cowboys.